# Patterning Techniques

A pattern is a repetition of shapes and lines that can be simple or complex depending on your preference and the space you want to fill. Even complicated patterns start out very simple with either a line or a shape.

## Repeating shapes (floating)

Shapes and lines are the basic building blocks of patterns. Here are some example shapes that we can easily turn into patterns:

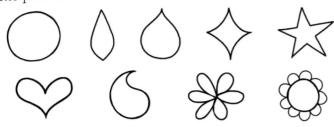

Before we turn these shapes into patterns, let's spruce them up a bit by outlining, double-stroking (going over a line more than once to make it thicker), and adding shapes to the inside and outside.

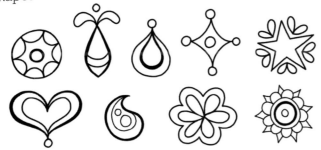

To create a pattern from these embellished shapes, all you have to do is repeat them, as shown below. You can also add small shapes in between the embellished shapes, as shown.

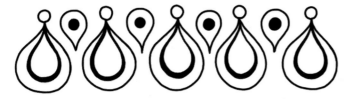

These are called "floating" patterns because they are not attached to a line (like the ones described in the next example). These floating patterns can be used to fill space anywhere and can be made big or small, short or long, to suit your needs.

> # Tip
> Draw your patterns in pencil first, and then go over them with black or color. Or draw them with black ink and color them afterward. Or draw them in color right from the start. Experiment with all three ways and see which works best for you!

> # Tip
> If you add shapes and patterns to these coloring pages using pens or markers, make sure the ink is completely dry before you color on top of them; otherwise, the ink may smear.

## Repeating shapes (attached to a line)

Start with a line, and then draw simple repeating shapes along the line. Next, embellish each shape by outlining, double-stroking, and adding shapes to the inside and outside. Check out the example below.

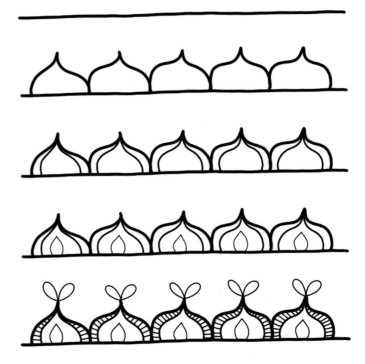

You can also draw shapes in between a pair of lines, like this:

## Embellishing a decorative line

You can also create patterns by starting off with a simple decorative line, such as a loopy line or a wavy line, and then adding more details. Here are some examples of decorative lines:

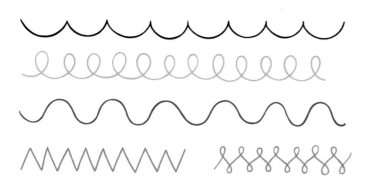

## Color repetition

Patterns can also be made by repeating sets of colors. Create dynamic effects by alternating the colors of the shapes in a pattern so that the colors themselves form a pattern.

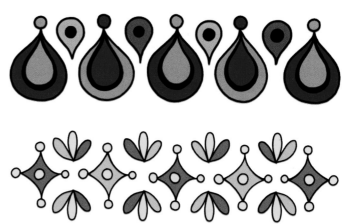

Next, embellish the line by outlining, double-stroking, and adding shapes above and below the line as shown here:

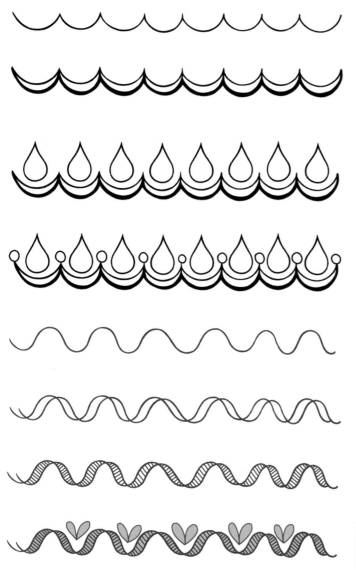

## Tip

Patterns don't have to follow a straight line—they can curve, zigzag, loop, or go in any direction you want! You can draw patterns on curved lines, with the shapes following the flow of the line above or below.

These types of patterns look great when attached to the inner or outer edge of a drawing, such as the inside of a flower petal or butterfly wing.

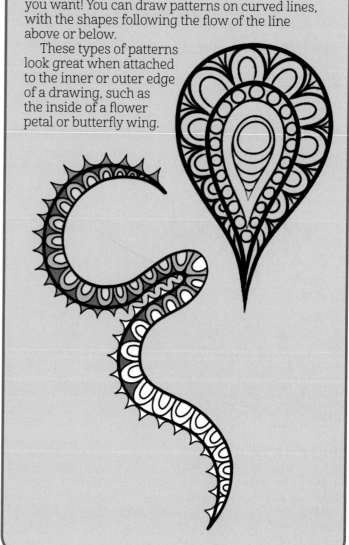

# Coloring Techniques & Media

My favorite way to color is to combine a variety of media so I can benefit from the best that each has to offer. When experimenting with new combinations of media, I strongly recommend testing first by layering the colors and media on scrap paper to find out what works and what doesn't. It's a good idea to do all your testing in a sketchbook and label the colors/brands you used for future reference.

### Markers & colored pencils

Smooth out areas colored with marker by going over them with colored pencils. Start by coloring lightly, and then apply more pressure if needed.

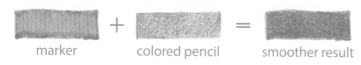

marker    +    colored pencil    =    smoother result

Test your colors on scrap paper first to make sure they match. You don't have to match the colors if you don't want to, though. See the cool effects you can achieve by layering a different color on top of the marker below.

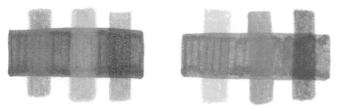

Markers (horizontal) overlapped with colored pencils (vertical).

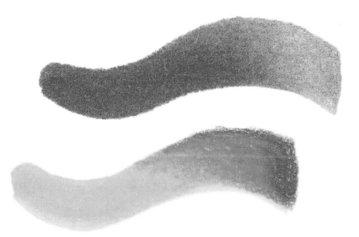

Purple marker overlapped with white and light blue colored pencils. Yellow marker overlapped with orange and red colored pencils.

### Markers & gel pens

Markers and gel pens go hand in hand, because markers can fill large spaces quickly, while gel pens have fine points for adding fun details.

White gel pens are especially fun for drawing over dark colors, while glittery gel pens are great for adding sparkly accents.

## Shading

Shading is a great way to add depth and sophistication to a drawing. Even layering just one color on top of another color can be enough to indicate shading. And of course, you can combine different media to create shading.

Colored with markers; shading added to the inner corners of each petal with colored pencils to create a sense of overlapping.

Colored and shaded with colored pencils.

Lines and dots were added with black ink to indicate shading and then colored over with markers.

# Color Theory

Check out this nifty color wheel. Each color is labeled with a P (primary), S (secondary), or T (tertiary). The **primary colors** are red, yellow, and blue. They are "primary" because they can't be created by mixing other colors. Mixing primary colors creates the **secondary colors** orange, green, and purple (violet). Mixing secondary colors creates the **tertiary colors** yellow-orange, yellow-green, blue-green, blue-purple, red-purple, and red-orange.

Working toward the center of the six large petals, you'll see three rows of lighter colors, called tints. A **tint** is a color plus white. Moving in from the tints, you'll see three rows of darker colors, called shades. A **shade** is a color plus black.

The colors on the top half of the color wheel are considered **warm** colors (red, yellow, orange), and the colors on the bottom half are called **cool** (green, blue, purple).

Colors opposite one another on the color wheel are called **complementary**, and colors that are next to each other are called **analogous**.

Look at the examples and note how each color combo affects the overall appearance and "feel" of the butterfly. For more inspiration, check out the colored examples on the following pages. Refer to the swatches at the bottom of the page to see the colors selected for each piece.

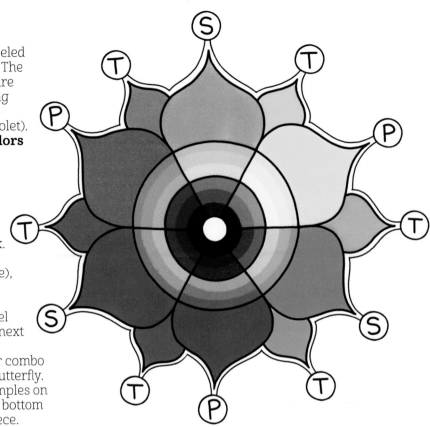

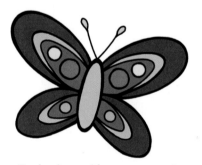

Warm colors

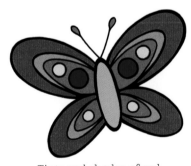

Cool colors

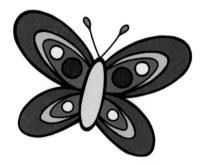

Warm colors with cool accents

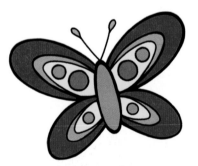

Cool colors with warm accents

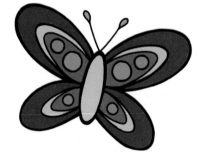

Tints and shades of red

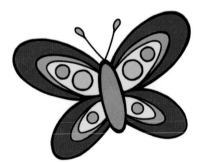

Tints and shades of blue

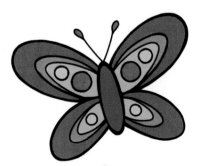

Analogous colors

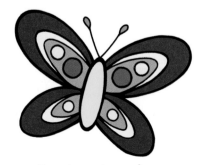

Complementary colors

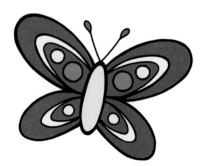

Split complementary colors

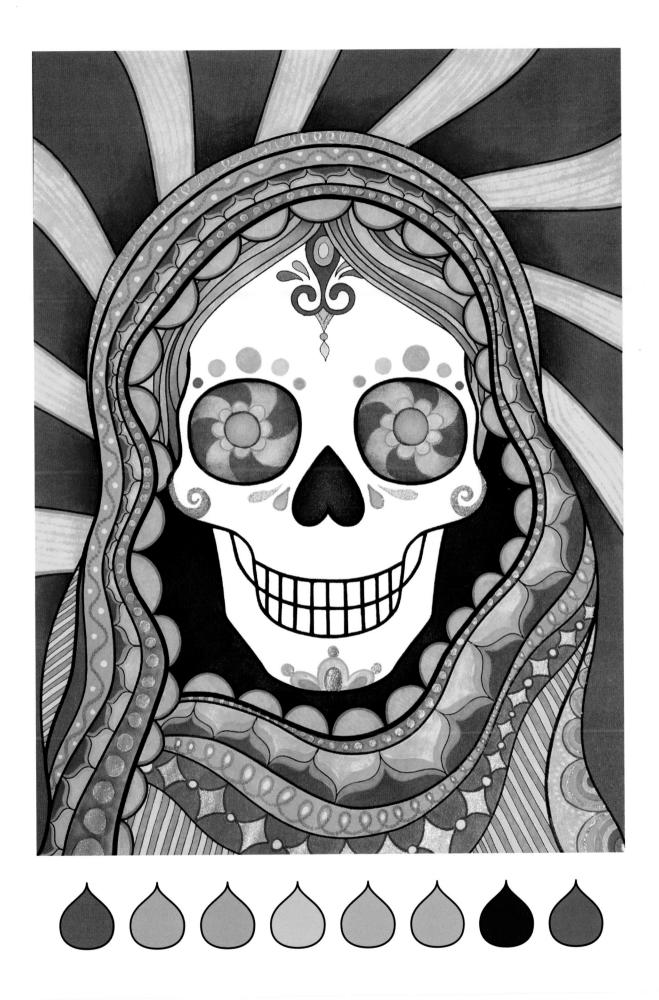

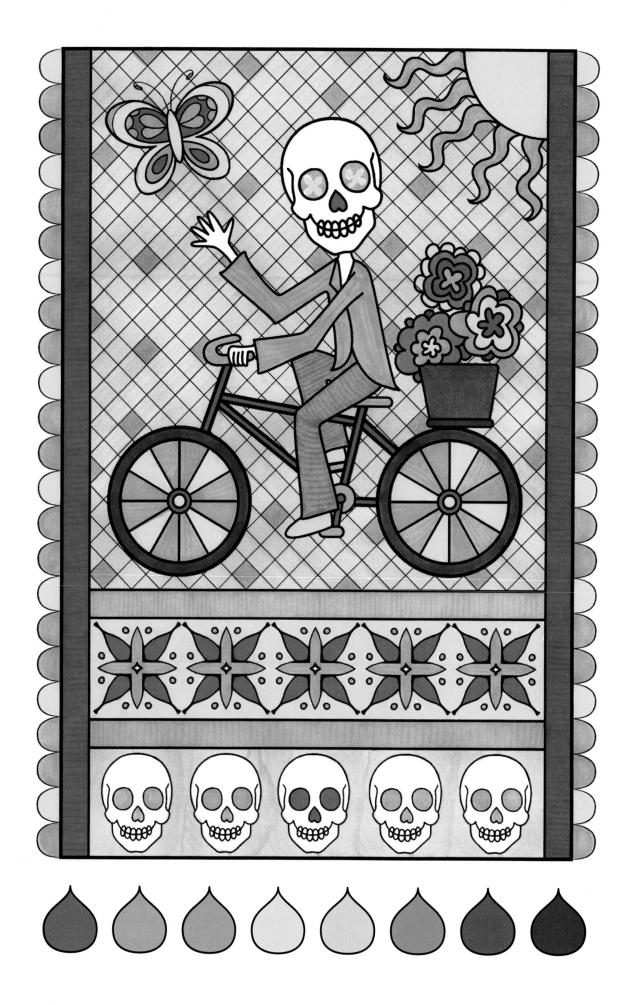

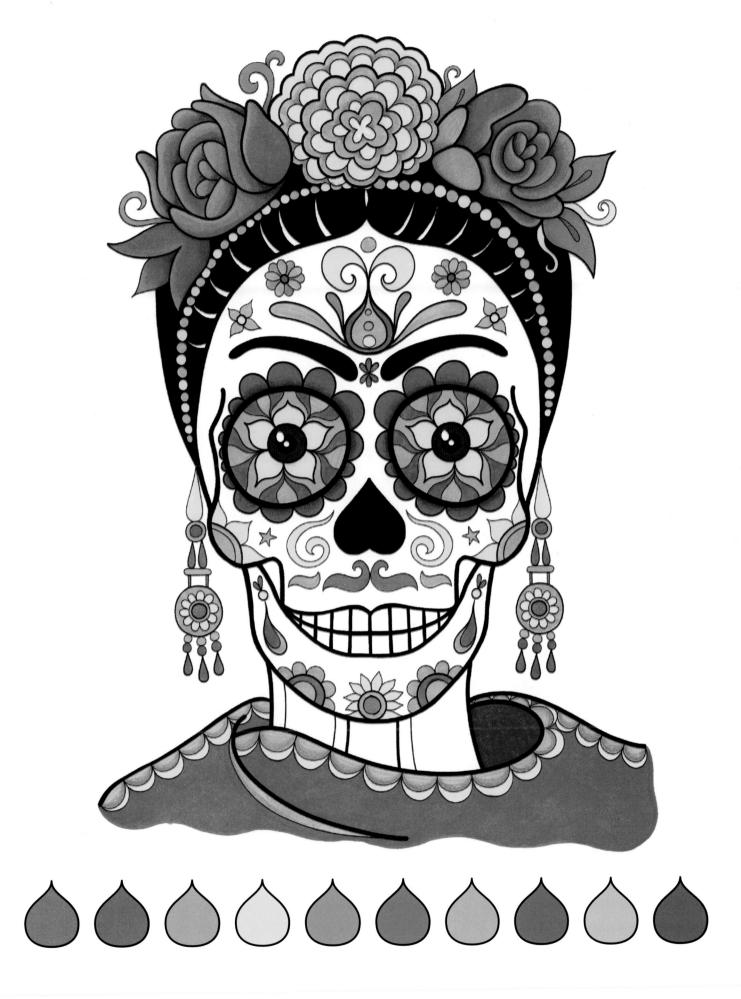

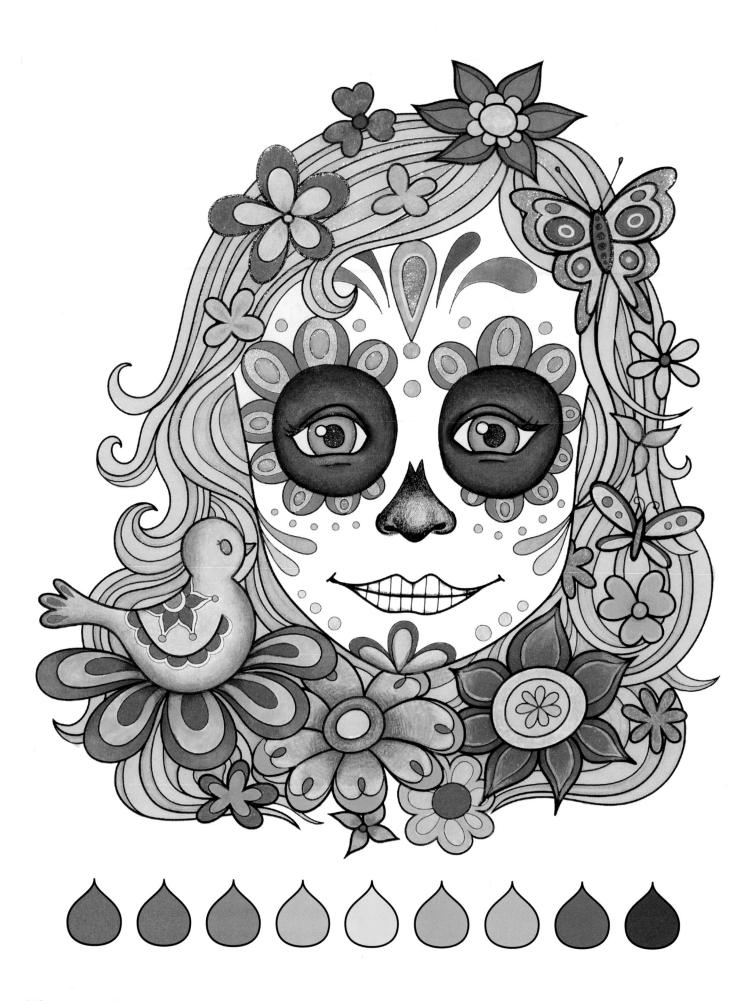

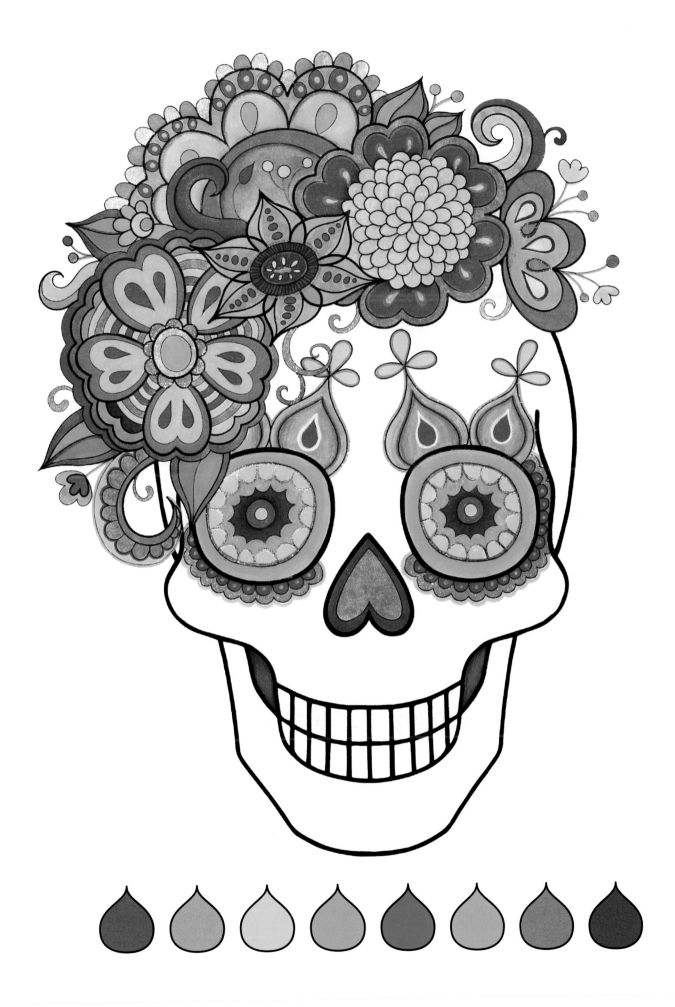

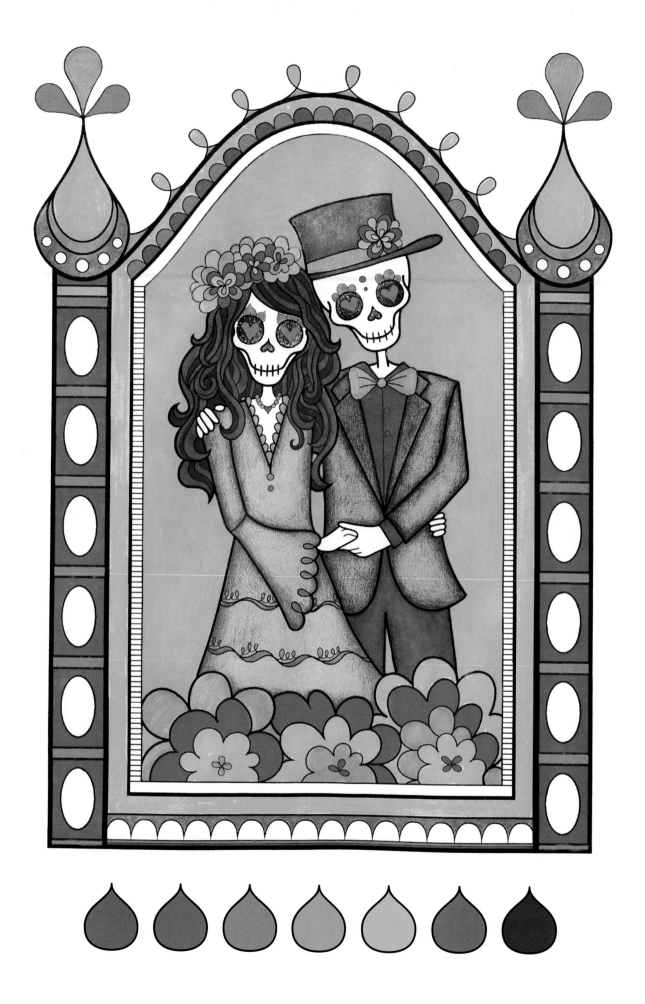

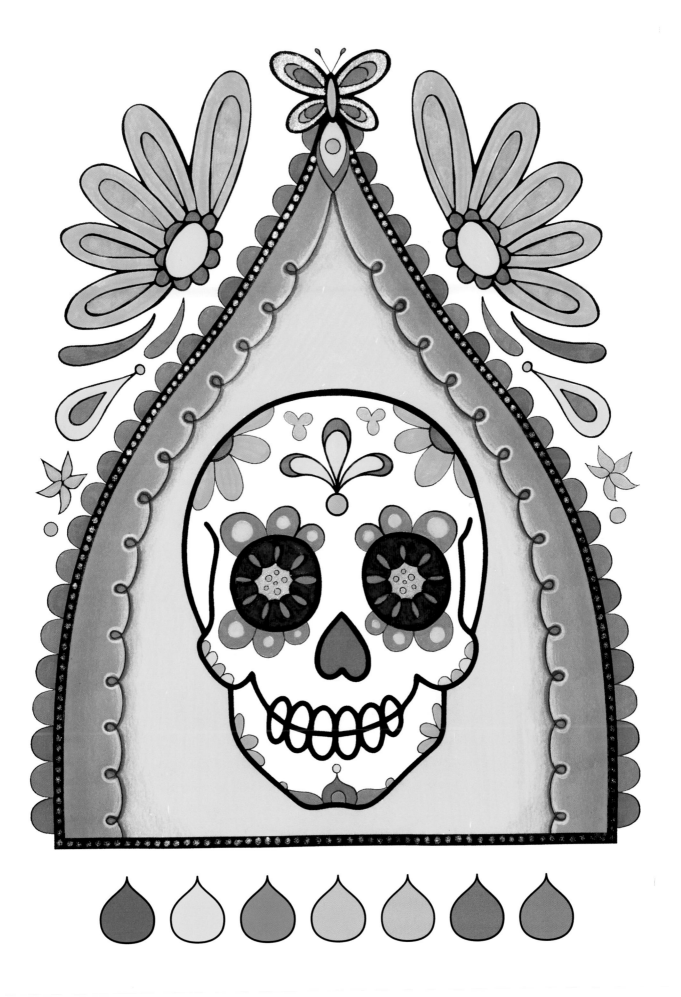

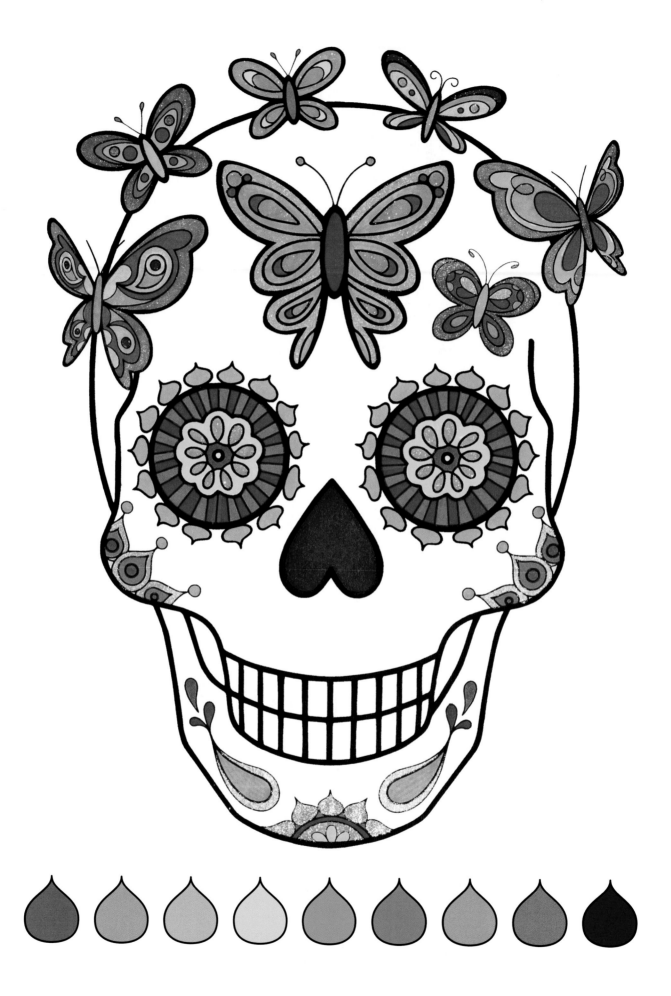

Be in love with your life. Every minute of it.

—Jack Kerouac

You only live once, but if you do it right, once is enough.

—Mae West

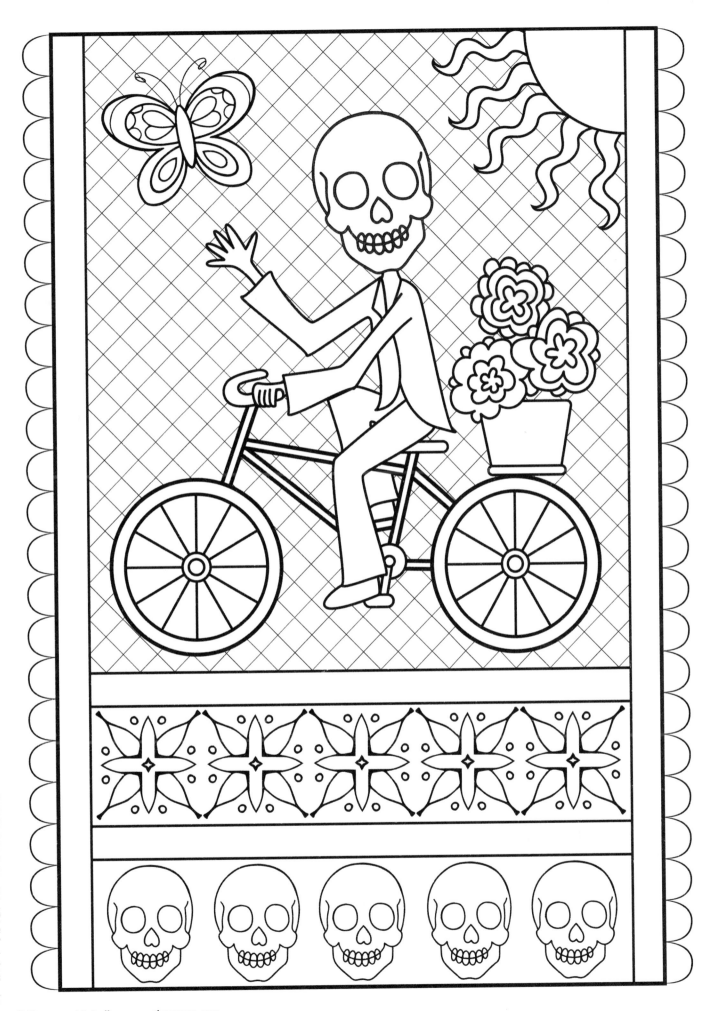

Dream as if you'll live forever.
Live as if you'll die today.

—James Dean

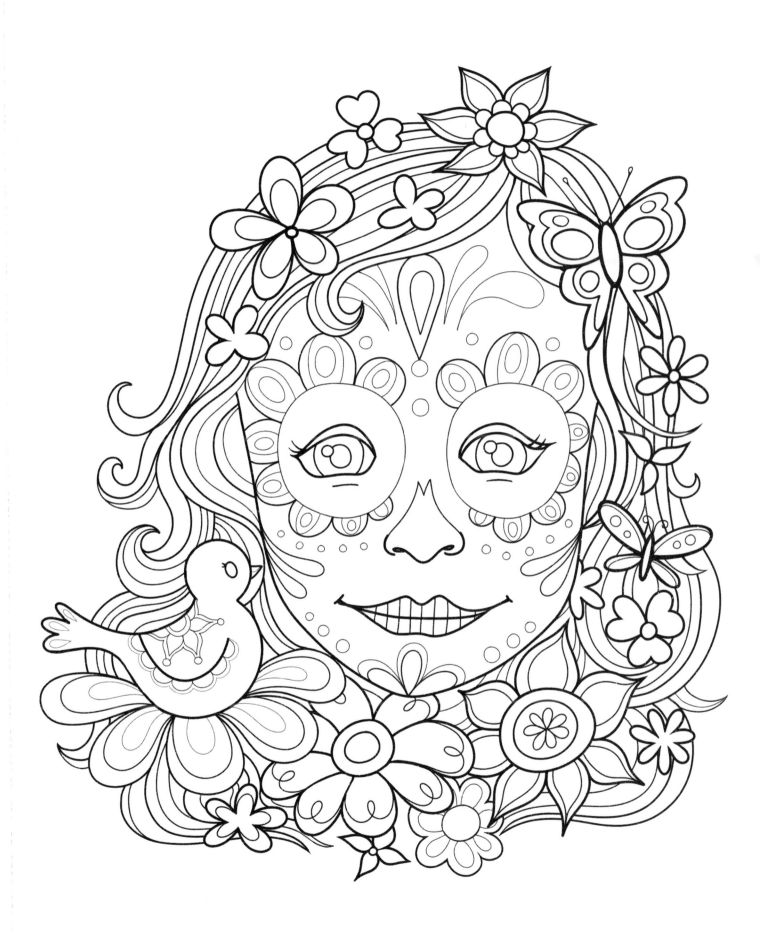

You were born a child of light's wonderful secret—
you return to the beauty you have always been.

—Aberjhani

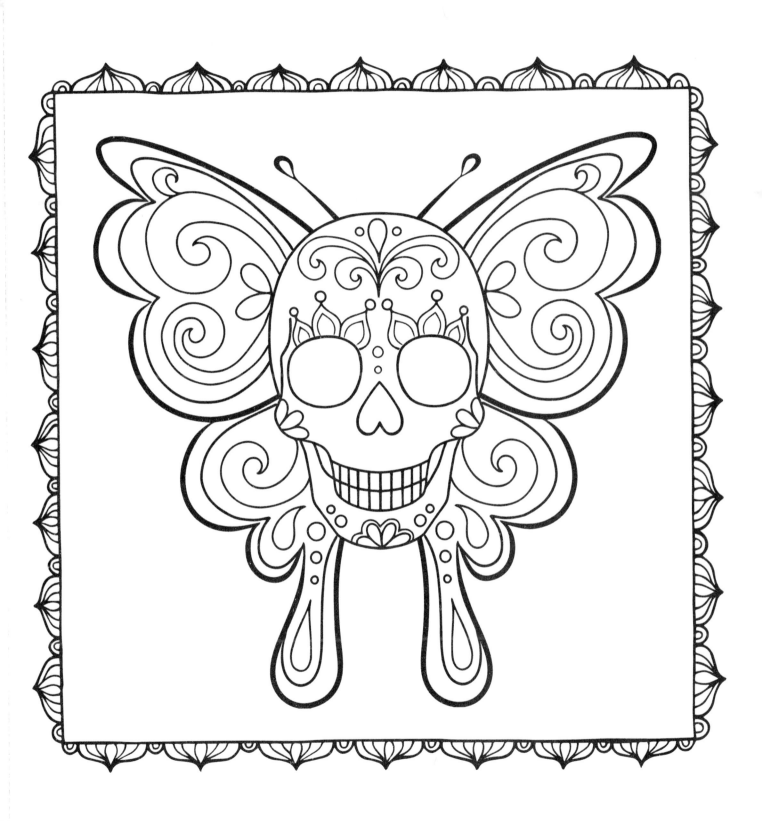

What the caterpillar calls the end of the world,
the master calls a butterfly.

—Richard Bach

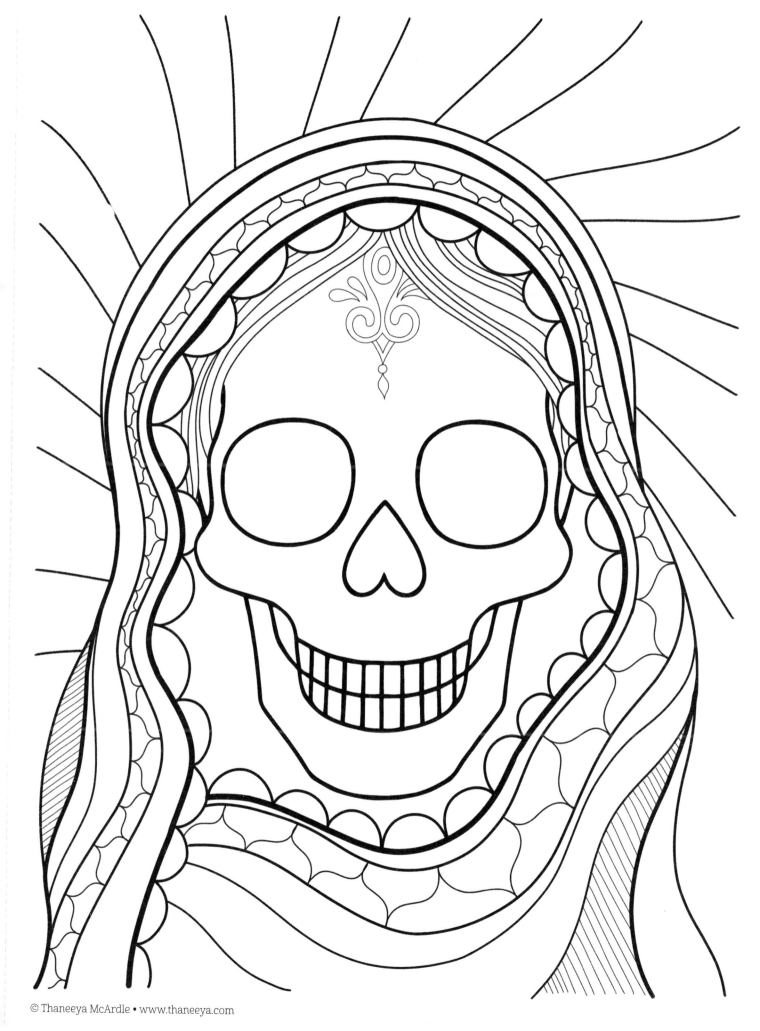

The most important thing is to enjoy your life—
to be happy—it's all that matters.

—Audrey Hepburn

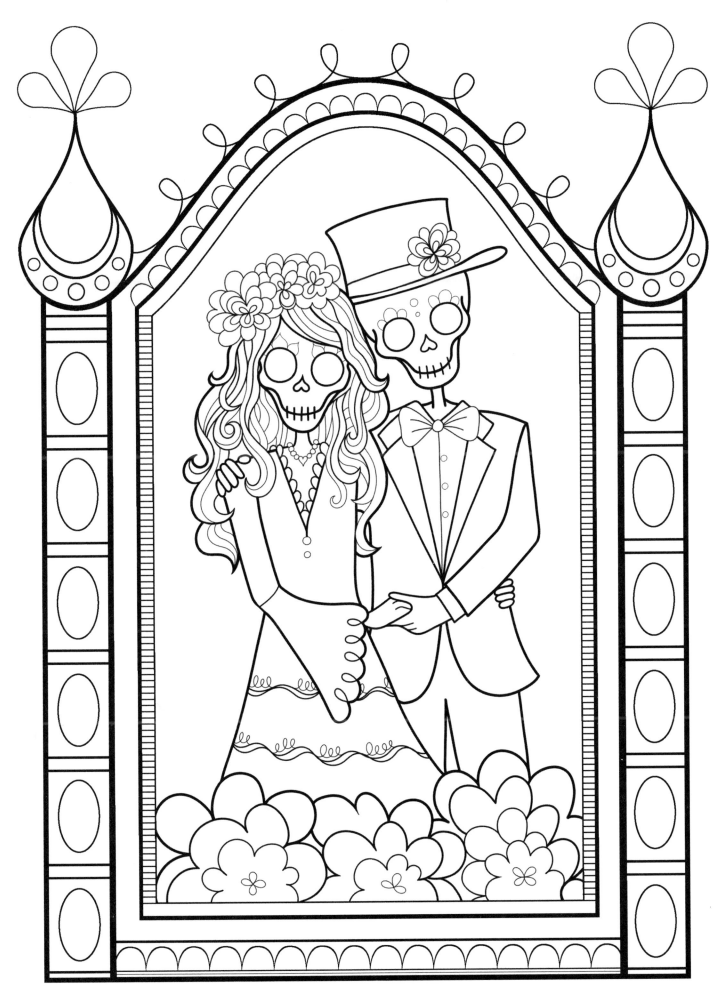

Where there is love there is life.

—Mahatma Gandhi

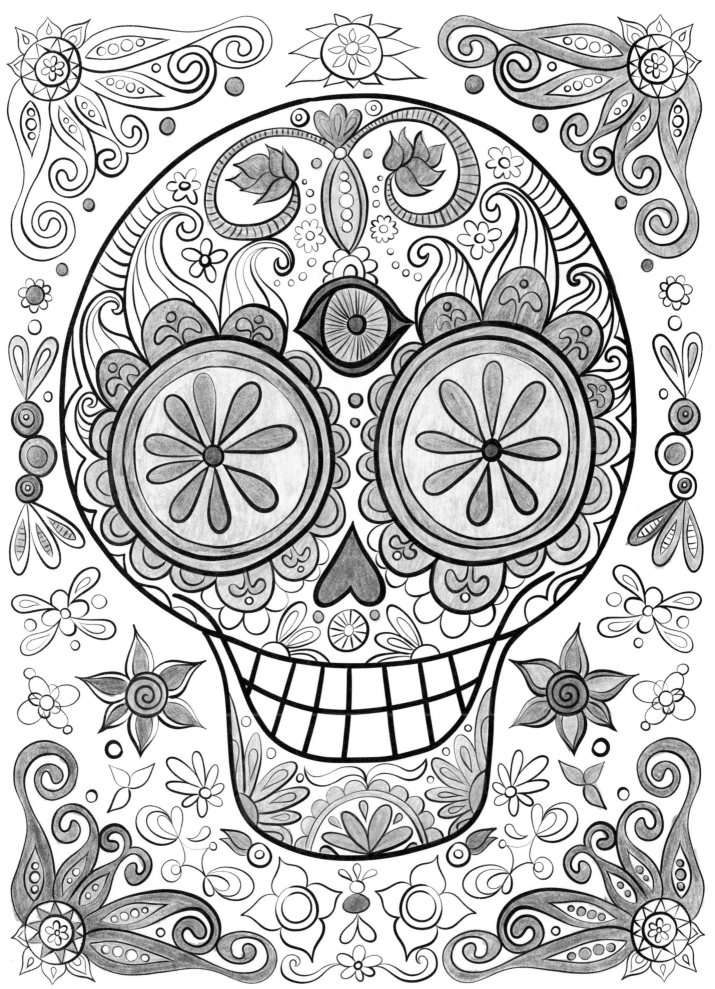

Life is a great big canvas, and you should throw
all the paint on it you can.

—Danny Kaye

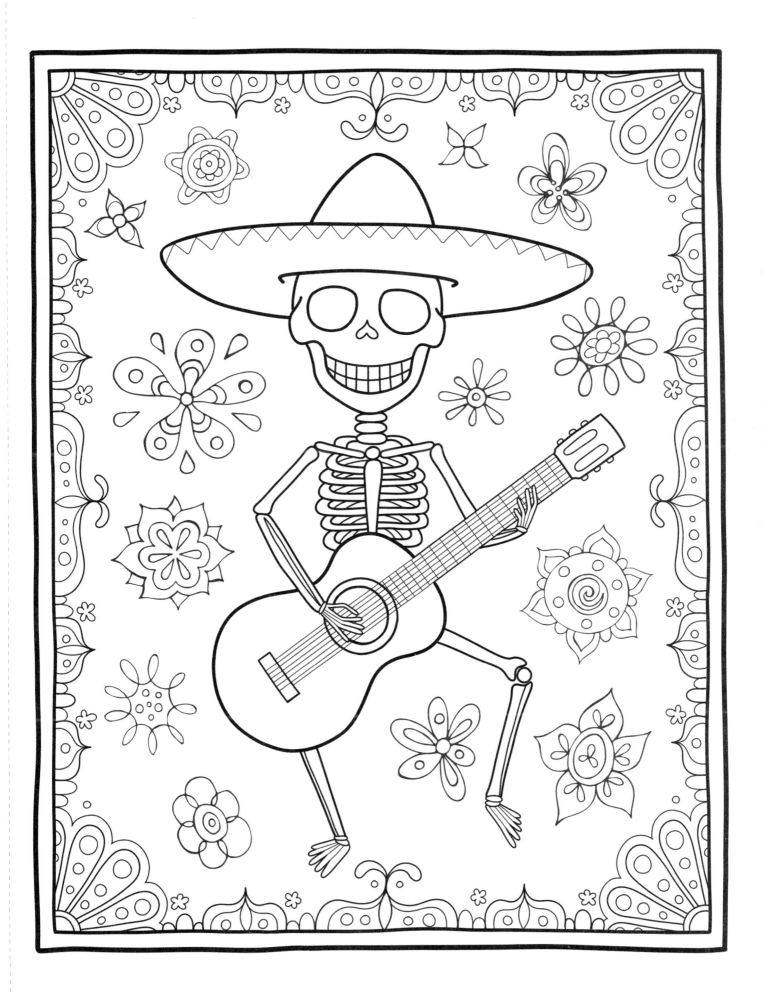

I am ready to meet my Maker.
Whether my Maker is prepared for the great
ordeal of meeting me is another matter.

—Winston Churchill

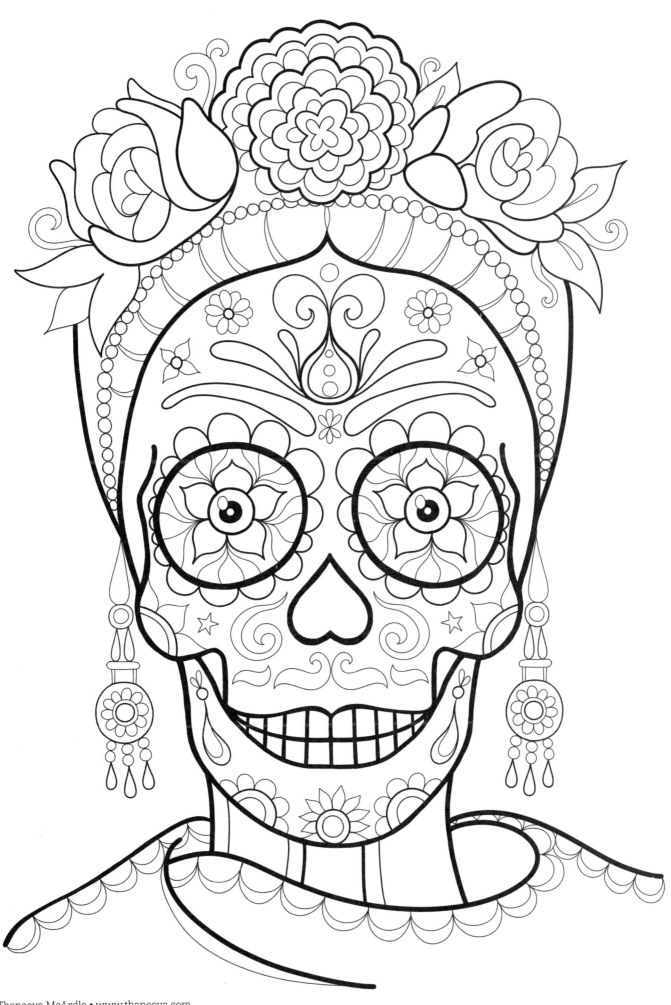

I never look back, darling. It distracts from the now.

—Edna Mode, *The Incredibles*

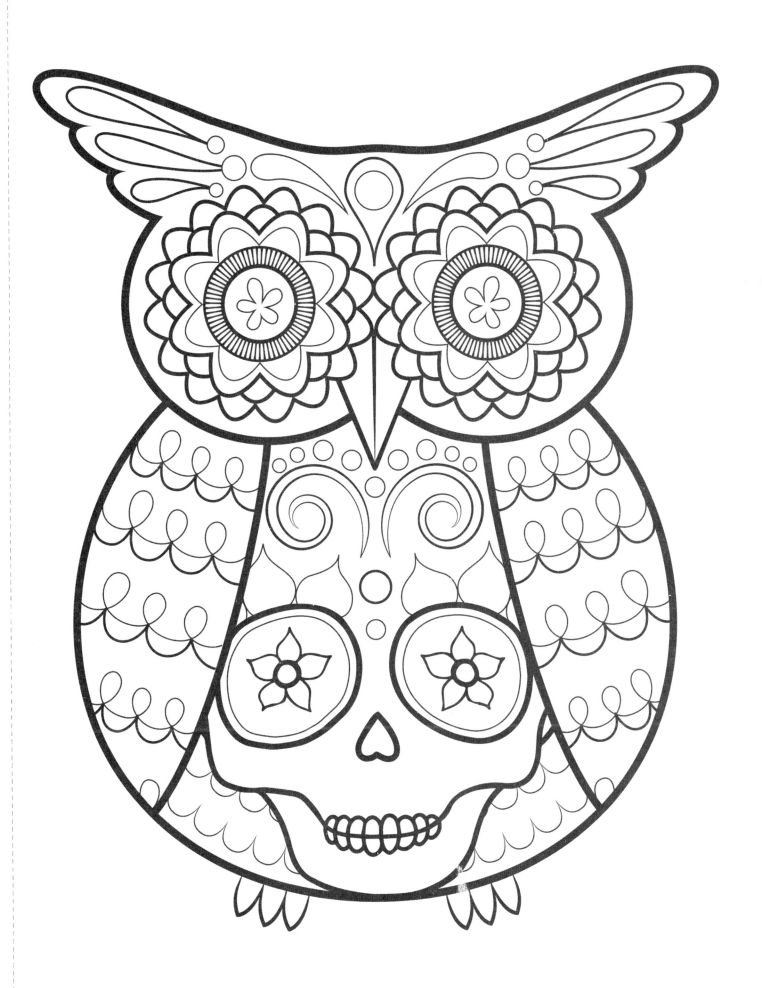

It does not do to dwell on dreams and forget to live.

—Dumbledore, *Harry Potter and the Sorcerer's Stone*

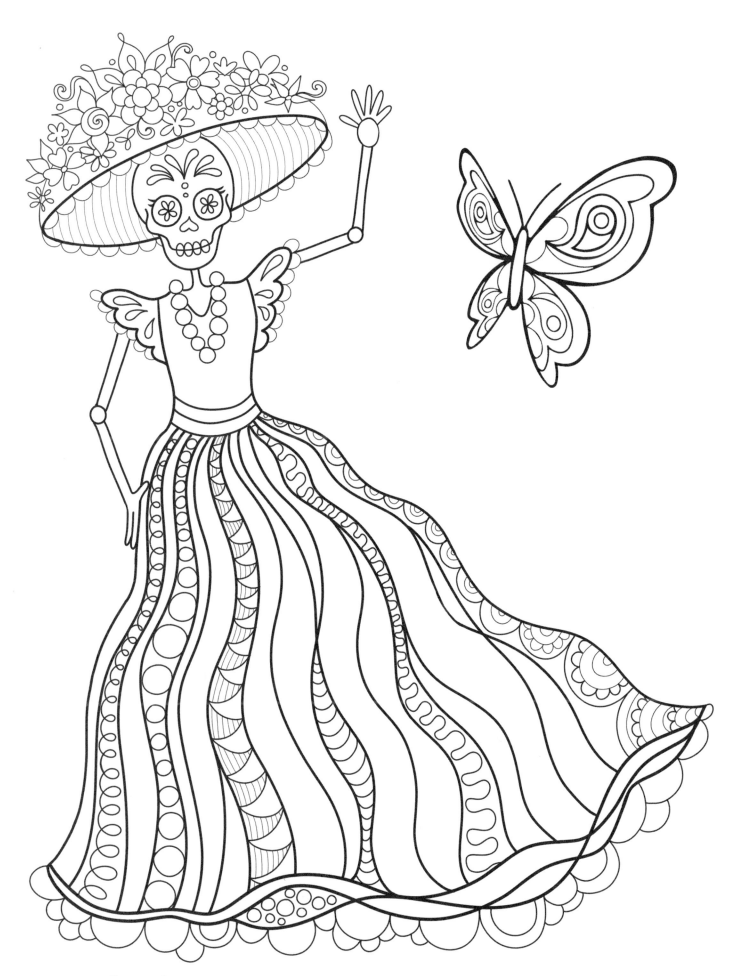

The purpose of life is to live it, to taste experience
to the utmost, to reach out eagerly and without fear
for newer and richer experience.

—Eleanor Roosevelt

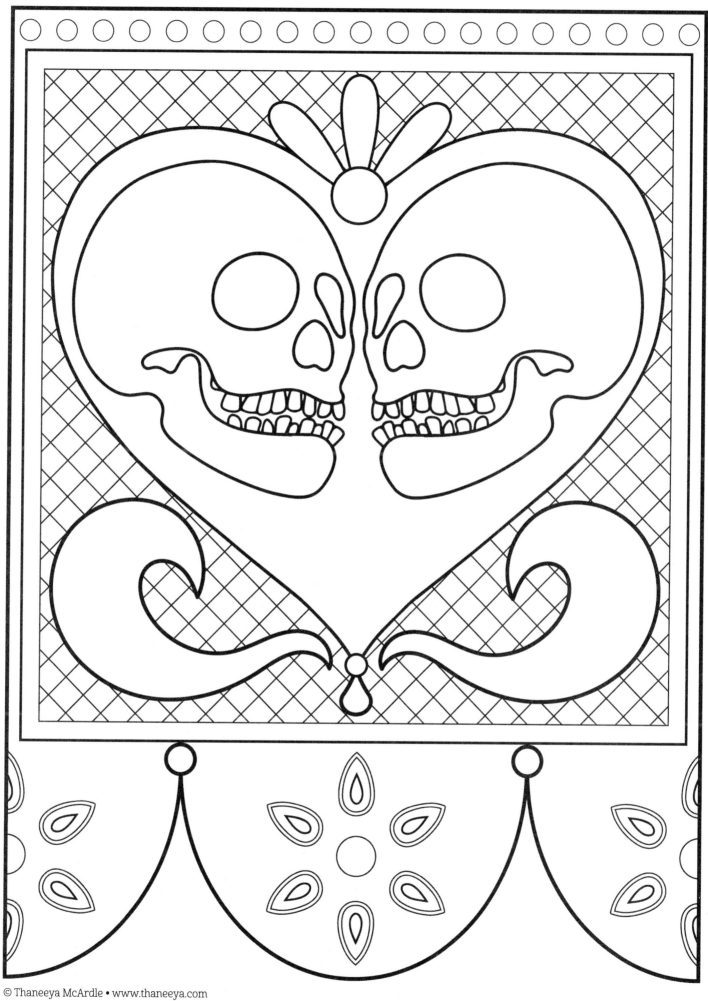

Don't count the days; make the days count.

—Muhammad Ali

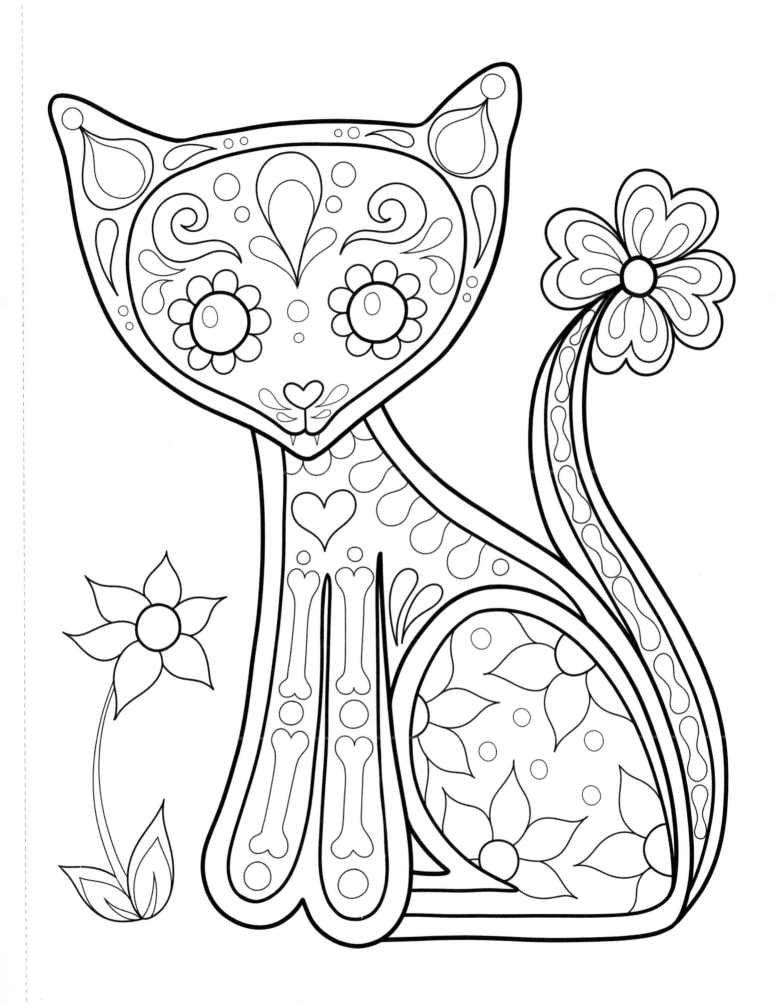

It's the Circle of Life
And it moves us all
Through despair and hope
Through faith and love
'Til we find our place
On the path unwinding
in the Circle, the Circle of Life

—Elton John, *The Circle of Life*

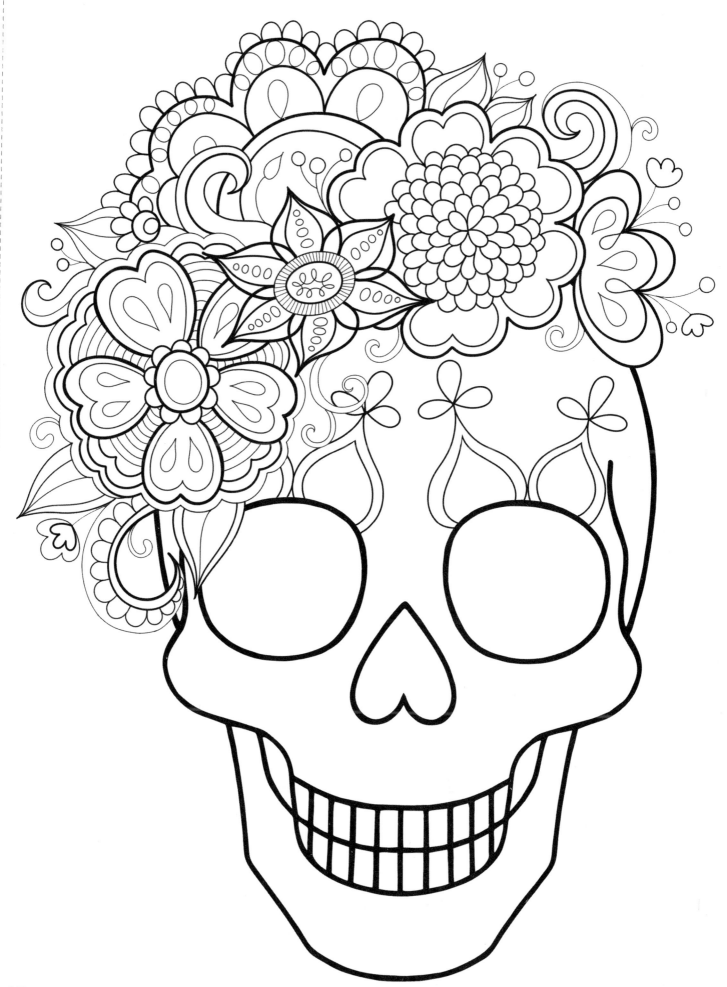

Each day comes bearing its own gifts.
Untie the ribbons.

—Ruth Ann Schabacker

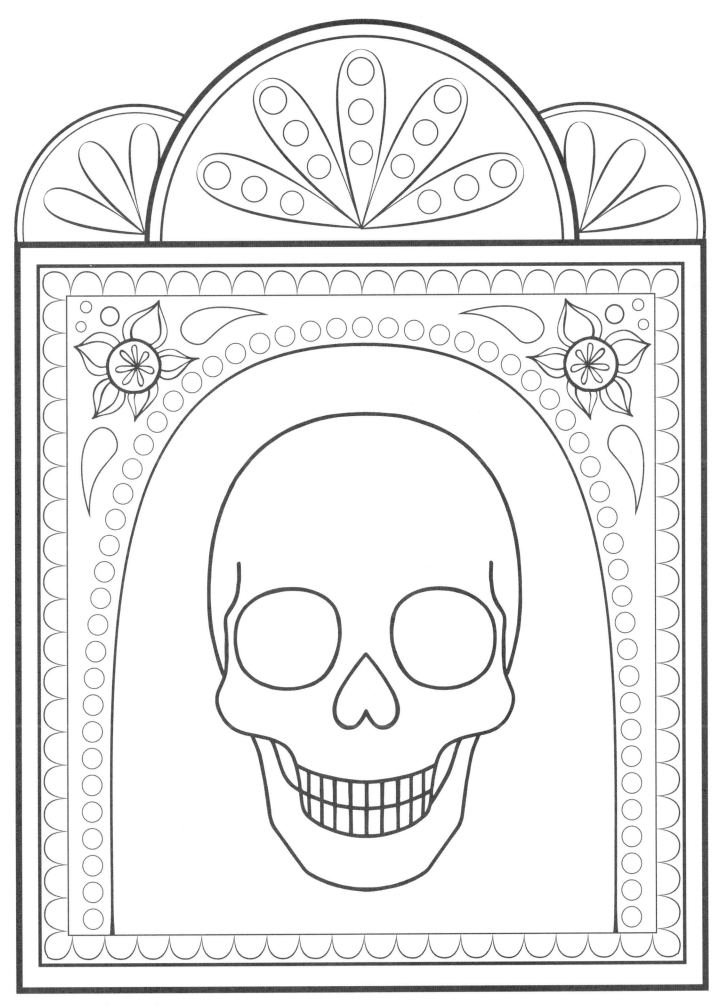

The best and most beautiful things
in the world cannot be seen or even touched.
They must be felt with the heart.

—Helen Keller

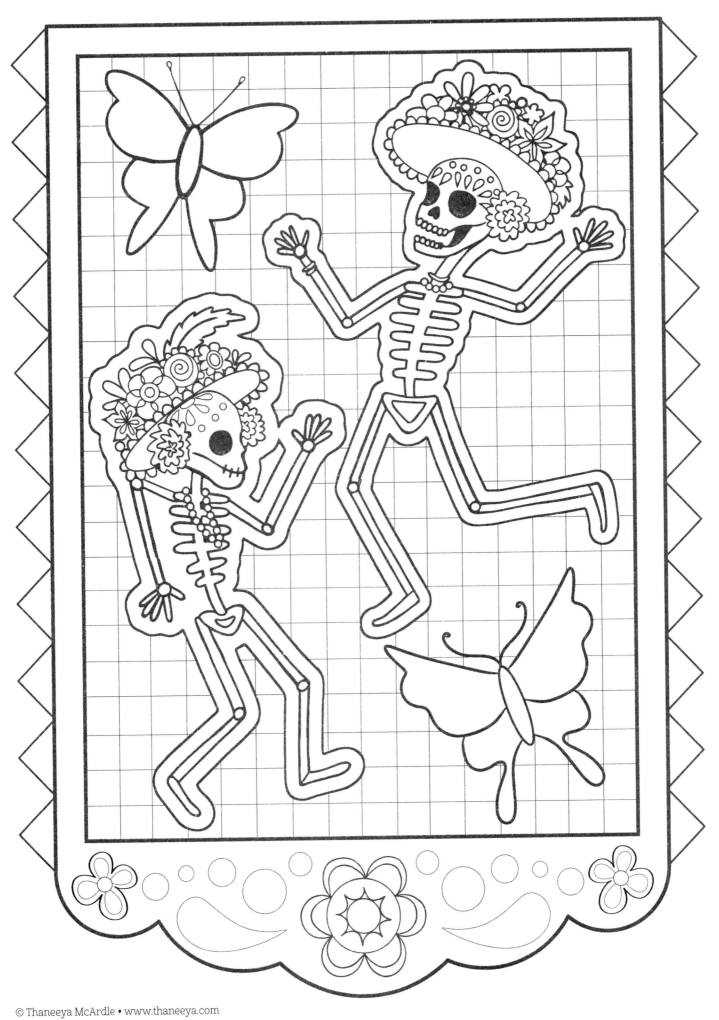

Every day brings a chance for you to draw in a breath,
kick off your shoes, and dance.

—Oprah Winfrey

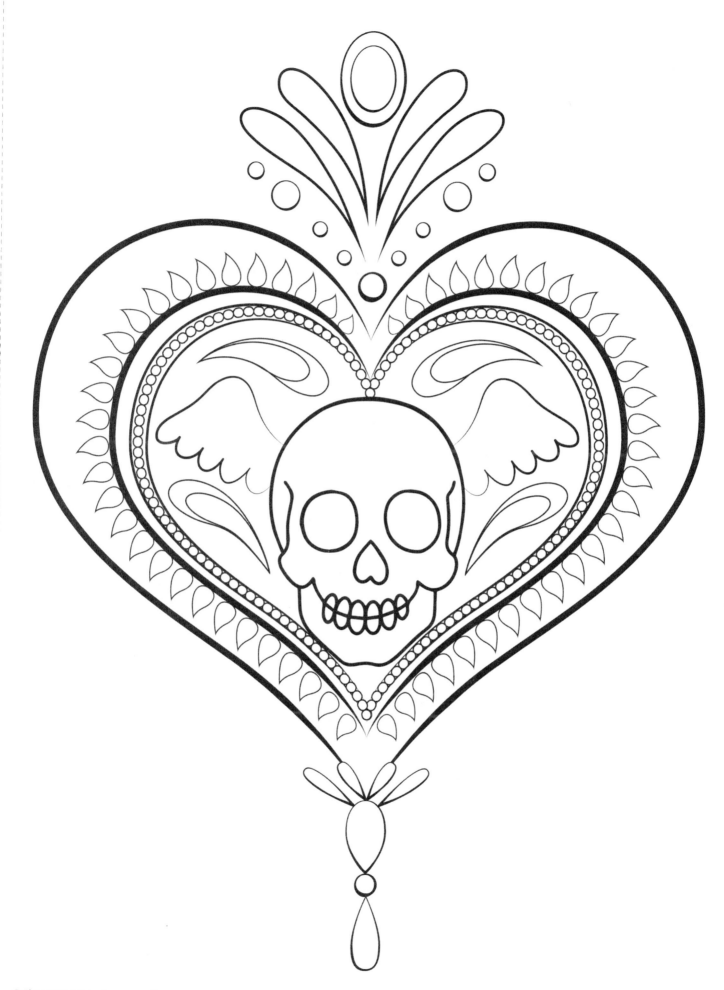

I would rather die of passion than of boredom.

—Vincent van Gogh

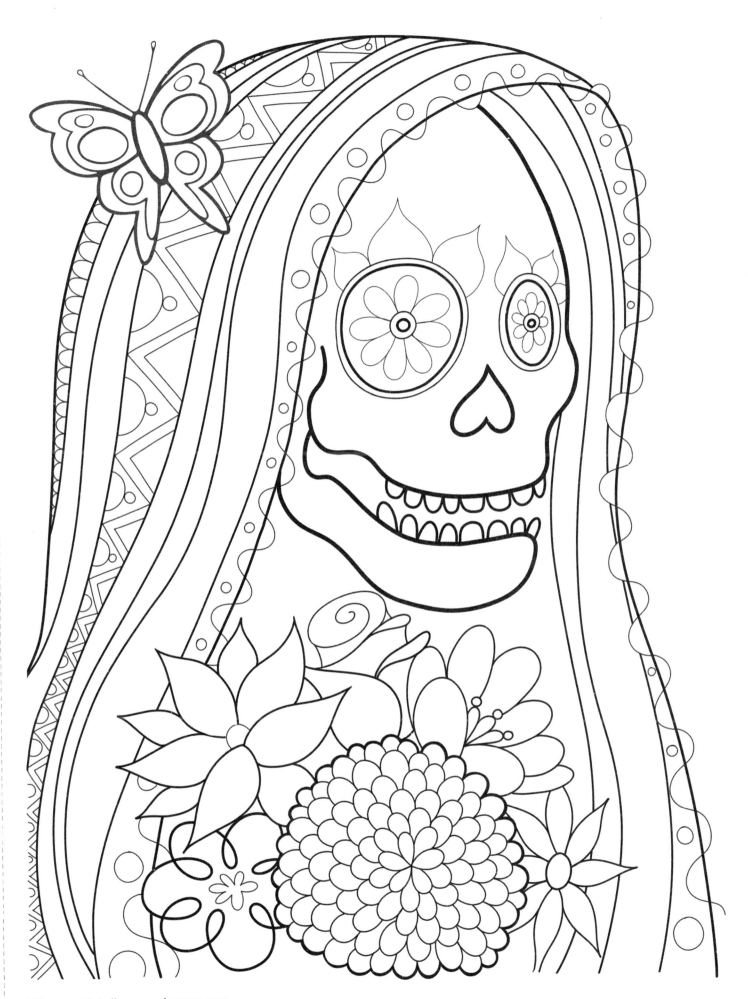

Life is not measured by the number of breaths we take,
but by the moments that take our breath away.

—Maya Angelou

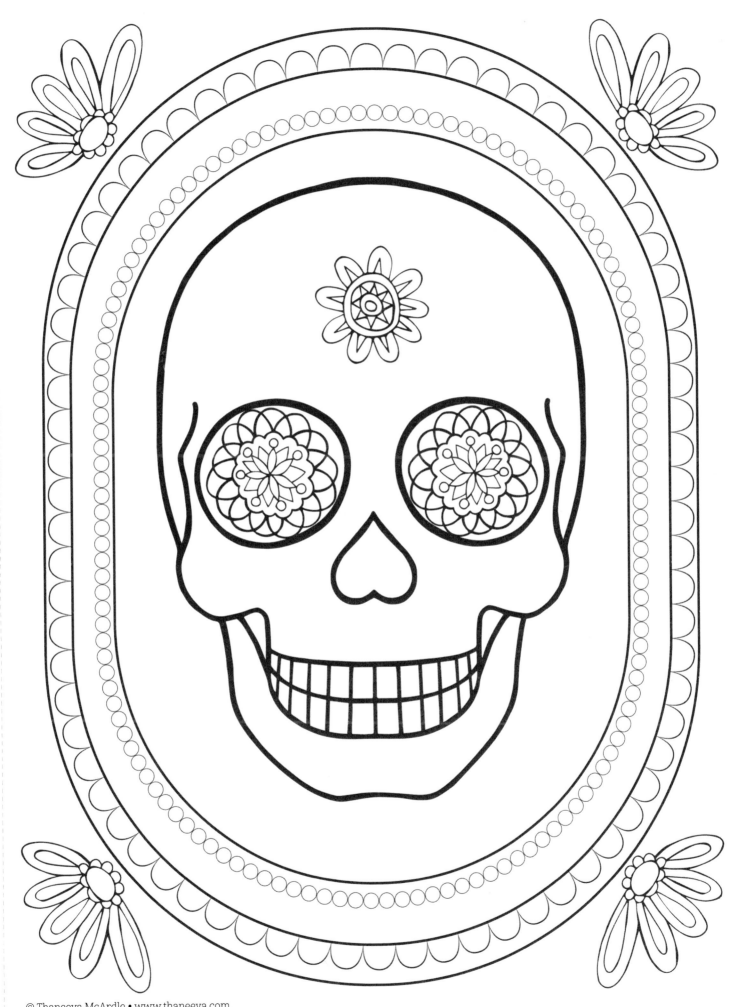

Begin doing what you want to do now.
We are not living in eternity.
We have only this moment,
sparkling like a star in our hand—
and melting like a snowflake.

—Sir Francis Bacon

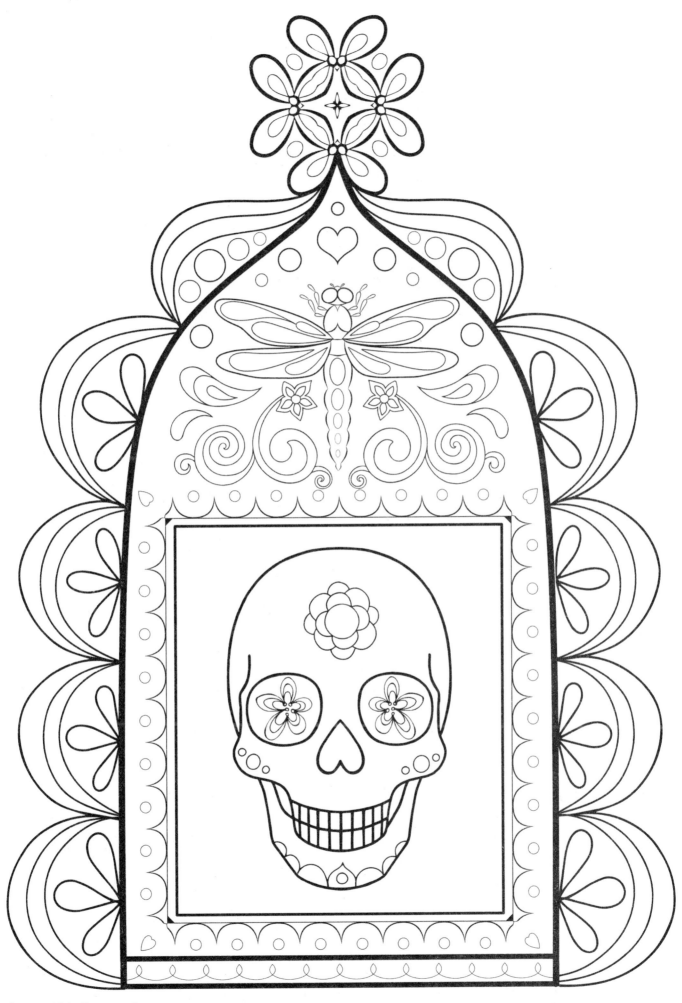

Life can only be understood backwards;
but it must be lived forwards.

—Søren Kierkegaard

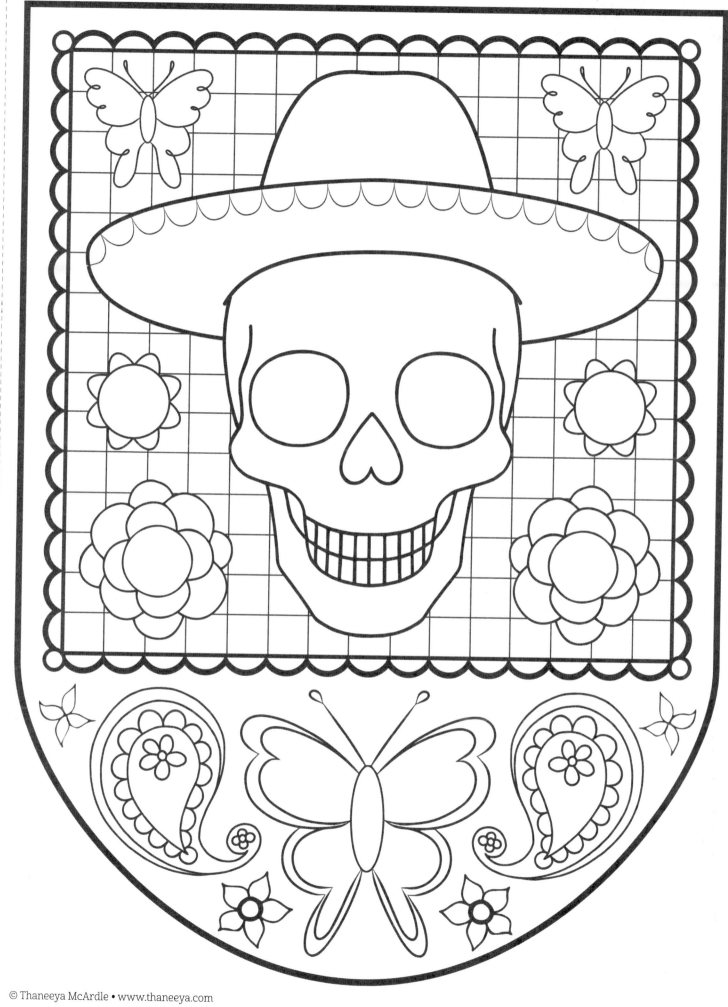

Do anything, but let it produce joy.

—Walt Whitman

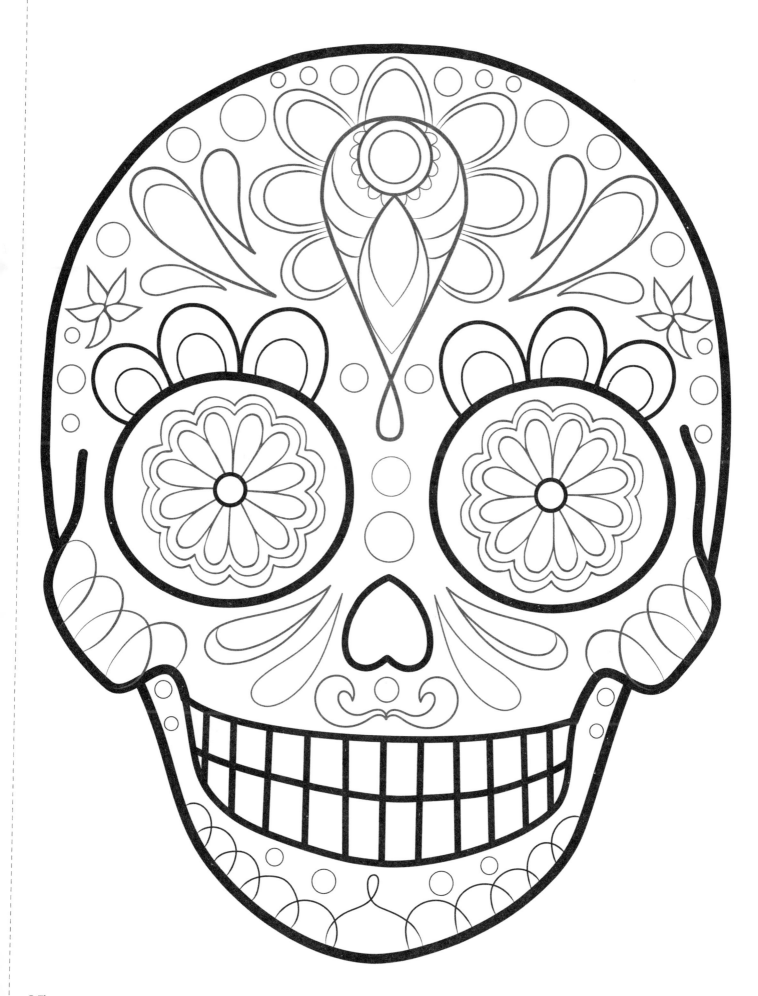

Set wide the window. Let me drink the day.

—Edith Wharton

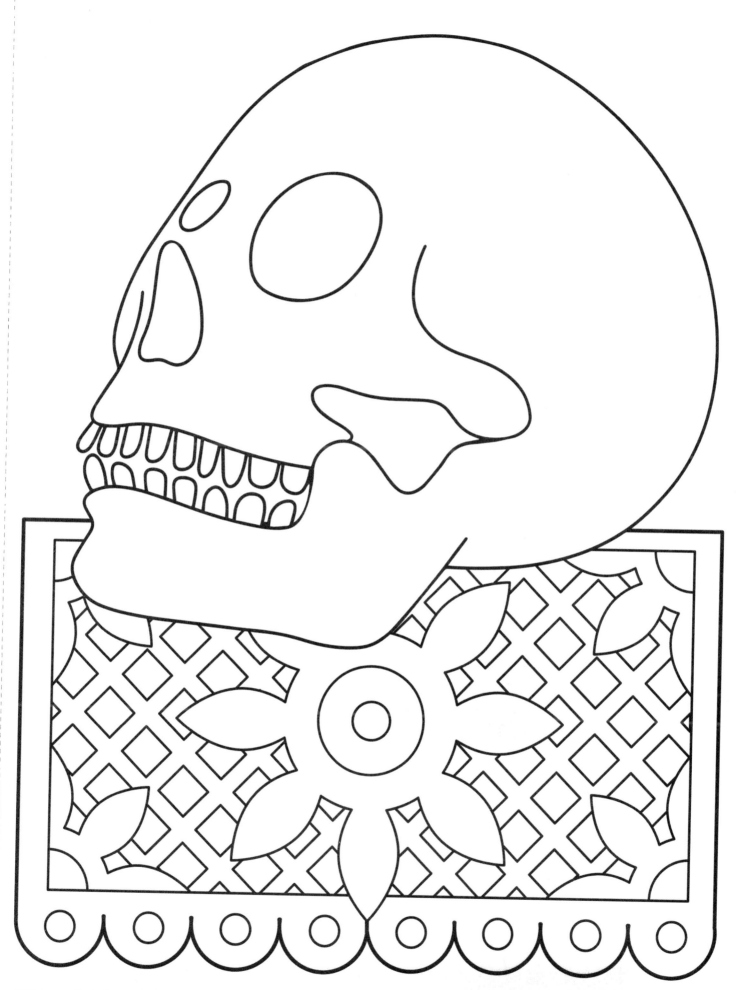

That it will never come again
is what makes life so sweet.

—Emily Dickinson

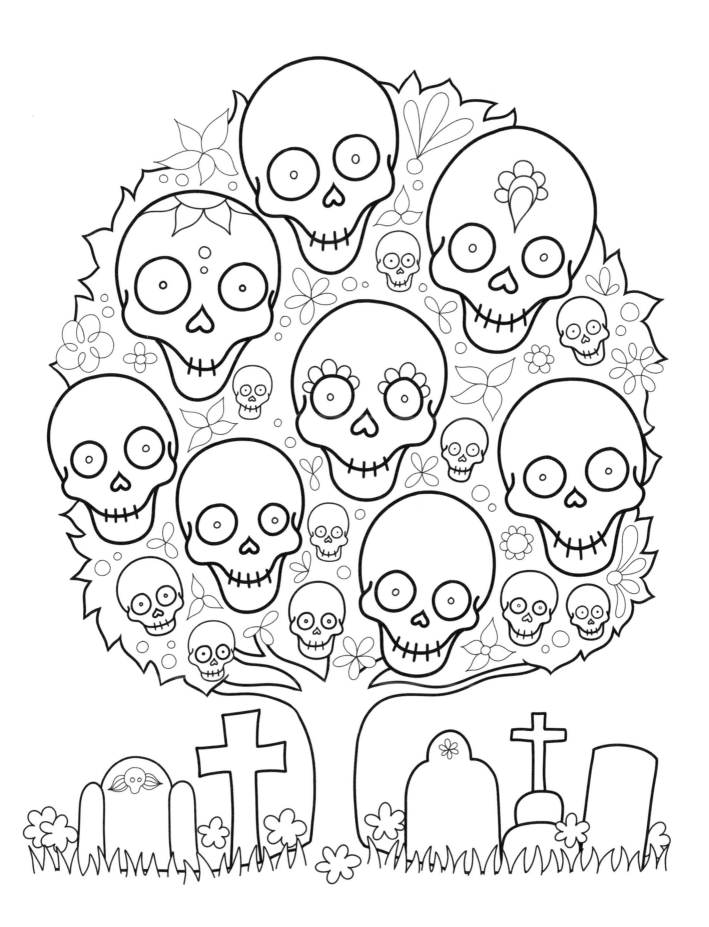

For life and death are one,
even as the river and the sea are one.

—Khalil Gibran

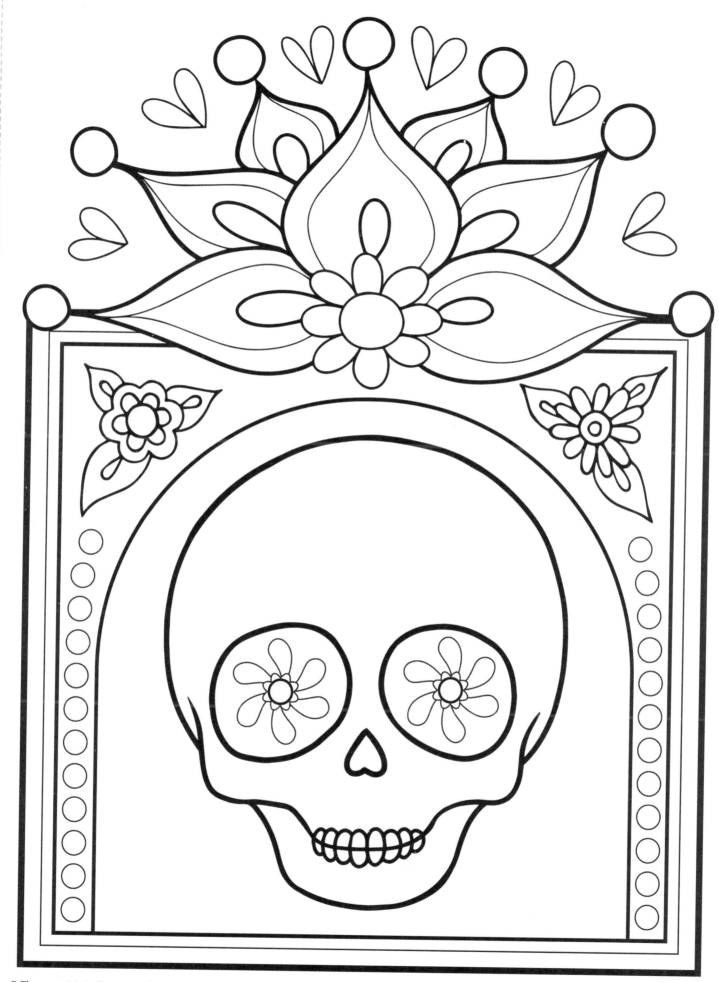

A life spent making mistakes
is not only more honorable, but more useful
than a life spent doing nothing.

—George Bernard Shaw

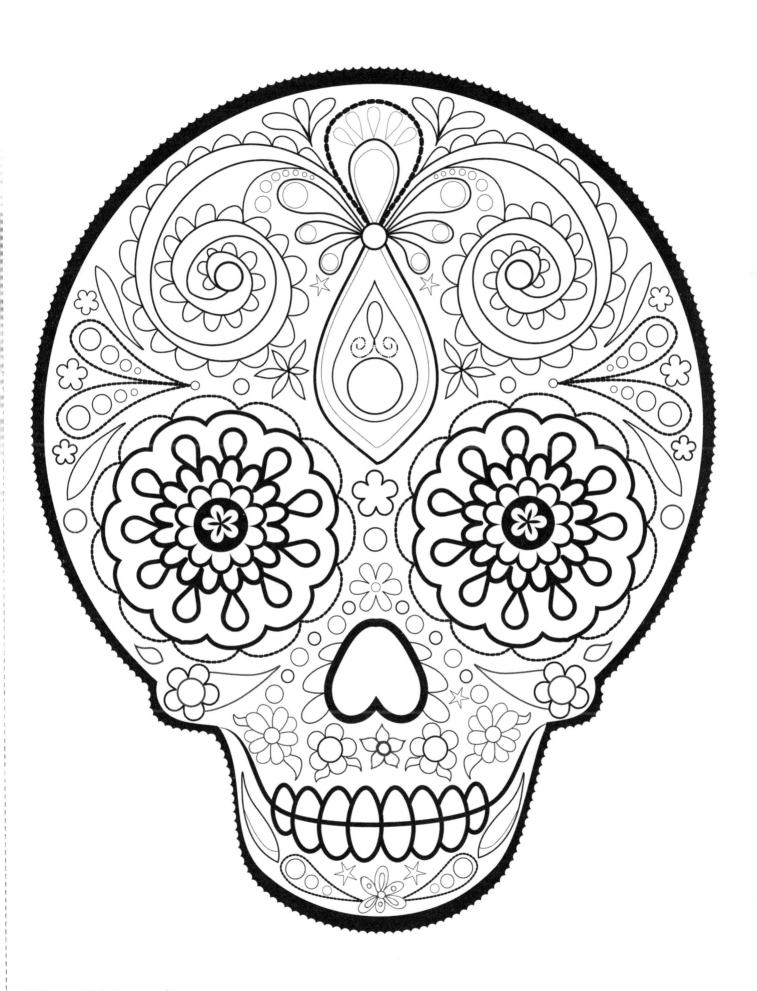

Life is either a daring adventure or nothing at all.

—Helen Keller

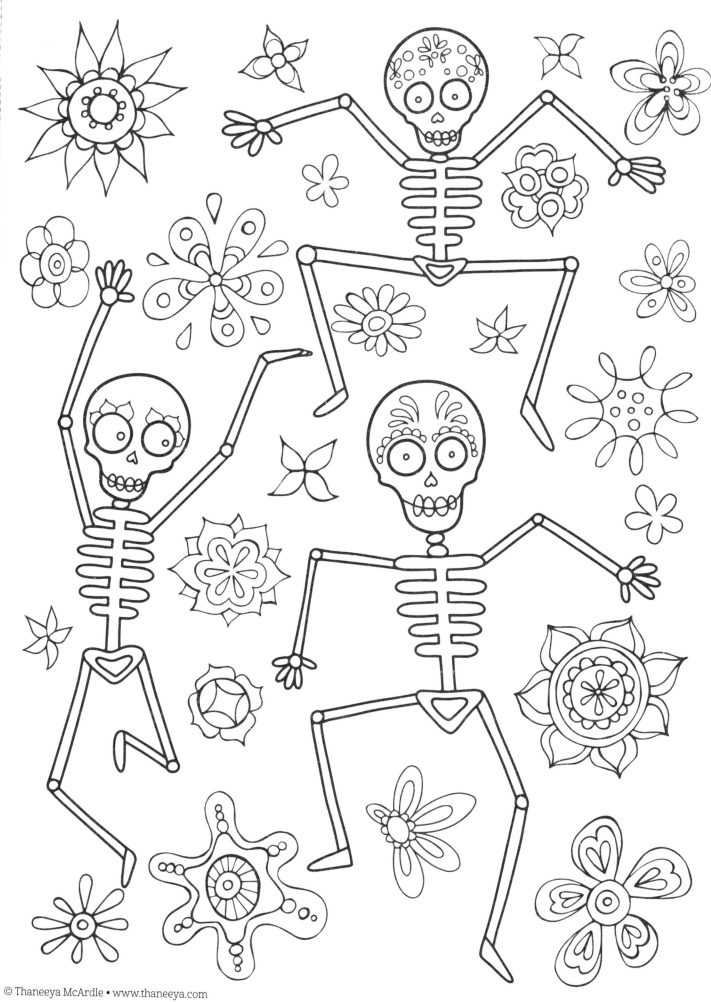

If you cannot get rid of the family skeleton,
you may as well make it dance.

—G. B. Shaw

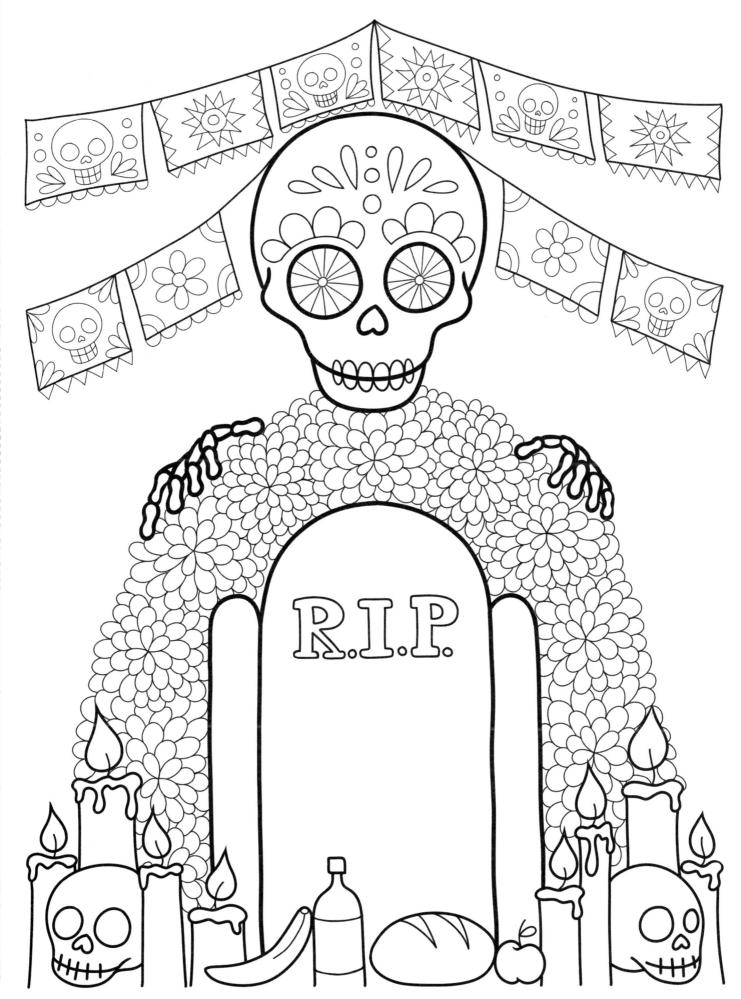

Nothing is worth more than this day.

—Johann Wolfgang von Goethe

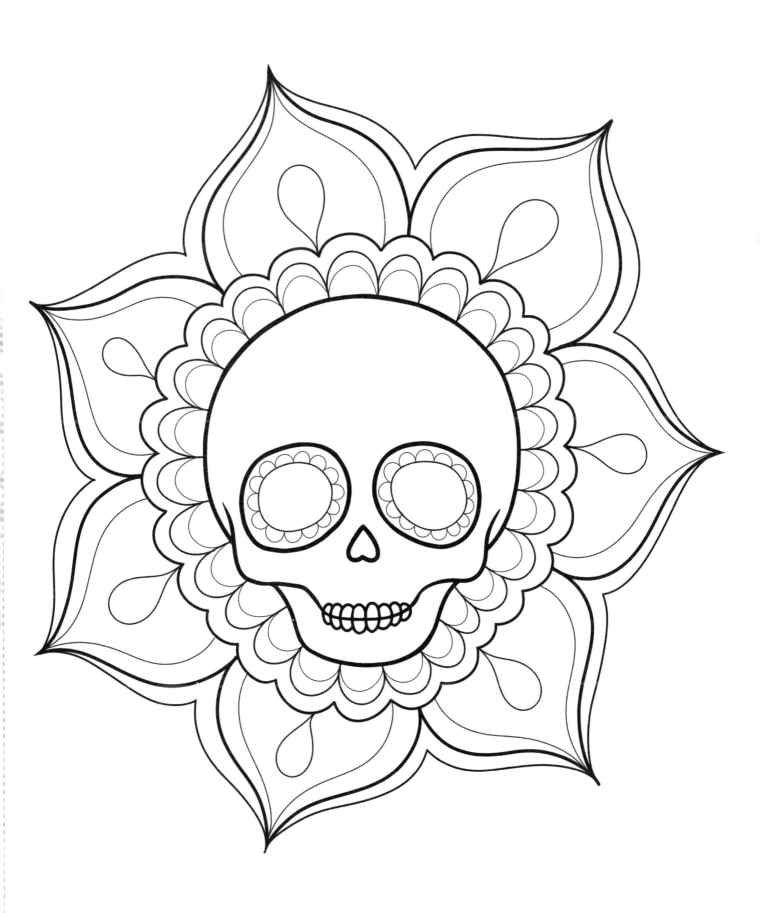

Oh, now, now, now, the only now, and above all now,
and there is no other now but thou now and now is thy prophet.

—Ernest Hemingway, *For Whom the Bell Tolls*